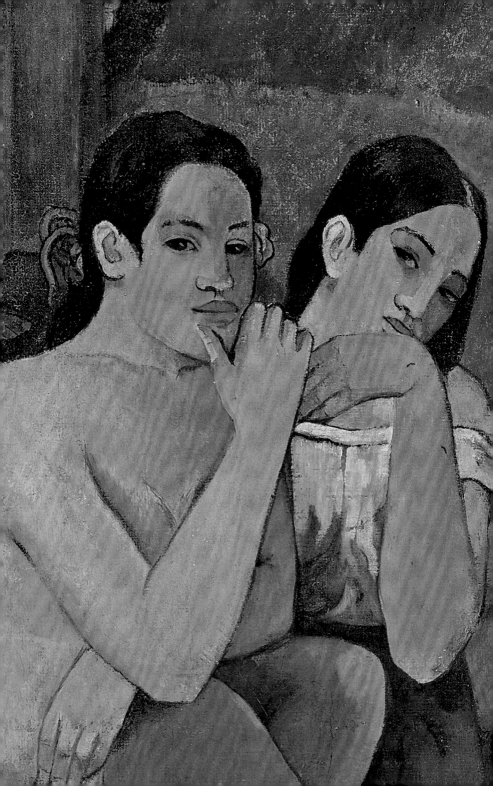

PAUL GAUGUIN

WHERE DO WE COME FROM?

WHAT ARE WE?

WHERE ARE WE GOING?

GEORGE T. M. SHACKELFORD

MFA PUBLICATIONS | MUSEUM OF FINE ARTS, BOSTON

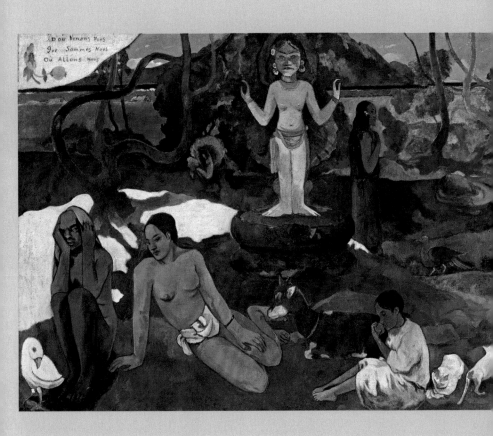

Where Do We Come From?
What Are We?
Where Are We Going?
1897–98

WHERE DO WE COME FROM?
WHAT ARE WE?
WHERE ARE WE GOING?

The painting begins with a question. The work was created, and the question asked, by an artist who was proud and vain but also deeply soul-searching and forever restless. That artist, Paul Gauguin, famously sought an escape from the corruption and demands of modern life, believing that he might find in the tropics of the South Seas a simpler lifestyle, his own personal idyll. In the Caribbean, in Tahiti, and then in the Marquesas Islands, he looked for answers to what he called the "ever-present riddle." "Where do we come from? What are we? Where are we going?" he asked, both in his writings and in the title he gave this monumental painting, the greatest masterwork of his Polynesian years. He went on:

What is our ideal, natural, rational destiny? And under what conditions can it be accomplished? or what is the law, what are the rules for accomplishing it in its individual and humanitarian meaning? . . . In these modern times, the human mind does need to solve [this riddle] in order to see the way before it clearly, in order to stride firmly toward its future without stumbling, deviating, or taking a step backward; and this must be done without wavering from the wise principle which consists of making a tabula rasa of all earlier tradition.[1]

Seeking for origins, trying to understand himself and humankind, his destiny—Gauguin's searching spirit led him to the riddle, not to its solution.

(detail)

Gauguin's experience of the world outside European metropolises was more extensive than that of any other French artist of his generation. In 1849, when the future artist was little more than a year old, his family emigrated to Peru, where his father hoped to prosper in his journalistic career. His father died on the way there, however, leaving Gauguin, along with his mother, Aline, and his sister, Marie, to the care of his maternal great-uncle in Lima. In 1855 the family returned to France.

Gauguin enlisted in the merchant marine in 1865, when he was seventeen, and thus resumed his career as a traveler, sailing around the world before leaving the service in 1871. Back in Paris, he sought the care and advice of Gustave Arosa, who had been his guardian before his majority (Gauguin's mother had died while he was away). Arosa was immersed in the world of art, as a photographer, a publisher, and a collector of modern French paintings. It was he who introduced Gauguin to his future wife, Mette Gad, a young Danish woman, whom the artist married in 1873. They would have five children together, the first, a son, in 1874.

At the time of his son's birth, Gauguin was working in the stock exchange, but he, along with Arosa, was seriously interested in painting. In fact, he had begun to paint, and in 1876 he successfully submitted a canvas to the Salon. Within the year, he was balancing his career as a stockbroker with that of a painter, a radical and risky position for a young man with relatively few connections to the establishment. Gauguin already had formed a small collection of paintings by the artists who became known as the Impressionists, showing a particular affinity for the works of Paul Cézanne and Camille Pissarro. He lent paintings by Pissarro to the Impressionist exhibition of 1879, and at the last minute he became an exhibitor, too.[2] Although he initially was admitted to this group of inde-

pendent artists as a talented amateur, he became a dedicated participant in the enterprise, showing at each of the remaining exhibitions held by the Impressionists in 1880, 1881, 1882, and 1886.

He decided to abandon the business of the stock market for the business of art in late 1883 when he moved his family from Paris to Rouen, in search of a less expensive life outside the French capital, in a smaller provincial city. Less than a year later, however, Mette and the children left France for Copenhagen, seeking her family's support. Gauguin joined them in Denmark at the end of the year, but by the summer of 1885 he had returned to Paris. The couple would remain apart, although in contact with each other, until a final rupture in 1897.

Gauguin's art-making was moving forward at a fast pace, as was his thinking about the nature of art and how it should be pursued. He had come to understand that art was not merely visual, but also deeply poetic and charged with emotions best expressed through the language of form and color. In a series of "Notes synthétiques" (Synthetic notes), written in 1885, he described painting as "the most beautiful of all the arts . . . the summation of all our sensations, and contemplating it we can each, according to our imagination, create the story, in a single glance our souls can be flooded with the most profound reflections; no effort of memory, everything summed up in a single instant."[3] At the same time—even, perhaps, as a logical next step—he came to the conclusion that his art, and possibly all good art, needed to evolve beyond its present state—above all, to break from Impressionism. This difference, he felt, had to be expressed not only in a work of art's emotional character but also in its physical appearance. In May 1885 he wrote to Pissarro that, as far as he was concerned, "there is no such thing as exaggerated art. And I even believe that there is salvation only in extremes."[4]

His search for these extremes took him from Paris to Brittany on the northwest coast of France, where he settled in Pont-Aven in July 1886. In the 1880s Brittany might rightly have been described as a ready-made paradise for modern painters, complete with thriving international artists' colonies and pensions eager to provide for creative talent looking for inspiration in the region's rocky pastures. Gauguin, however, had other things in mind than the transcription of the picturesque countryside peopled by simple peasants. He admired Brittany not for its quaintness but for its underlying coarseness, its brutality, what he called in a letter to his painter friend Émile Schuffenecker the region's "savage, primitive quality," continuing, "When my clogs echo on this granite ground, I hear the dull, muted, powerful sound I am looking for in painting."[5]

Seeking inspiration from places even more remote, in April 1887 Gauguin traveled to the Caribbean, working briefly as a laborer on the Panama Canal and then settling in the French colony of Martinique, where he remained for several months. There, too, his attention turned to the lives of the men, women, and children he saw around him — "the continual to-and-fro of Negro women dressed in colorful rags, with an infinite variety of graceful movements."[6] The dreamy quality of what Gauguin painted in the tropics of the New World demonstrates a more fluid side of the primitive idylls that had resulted from his close contact with the Breton peasantry. A critic praised Gauguin's rendering of this other world, admiring the "undergrowth full of monstrous vegetation and flora, with its formidable torrents of sun," and finding in the works "an almost religious mystery, a sacred abundance quite Edenic."[7]

Gauguin departed Martinique for France in the autumn of 1887, returning to Pont-Aven by early 1888. Shortly thereafter, his friend Vincent van Gogh determined to leave Paris for the south of France. Gauguin remained

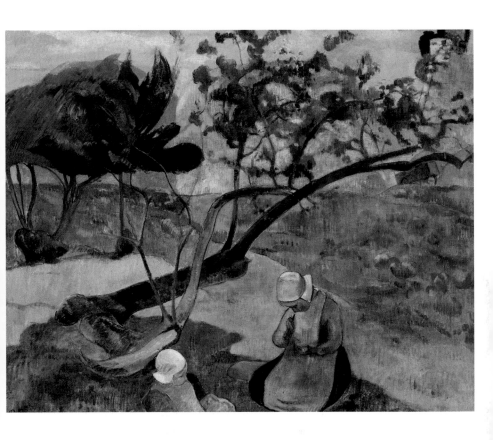

Landscape with Two Breton Women, 1889

behind, confirmed in his preference for the rocky sea-side country of the northwest.[8] But by that October he was persuaded by his friend and his friend's brother Theo van Gogh—who happened to be a dealer whose favor Gauguin much wanted to curry—to join Vincent in the "studio of the south," and to realize there, however tentatively, the Dutchman's fantasy of a utopian community of artists, working in harmony with one another and with nature. The story of their tumultuous time together—filled with inspiration, exasperation, and ultimately despair—is legendary; by Christmastime Gauguin abandoned the unhappy Van Gogh in the hospital at Arles, returning to Paris and its avant-garde milieu.[9]

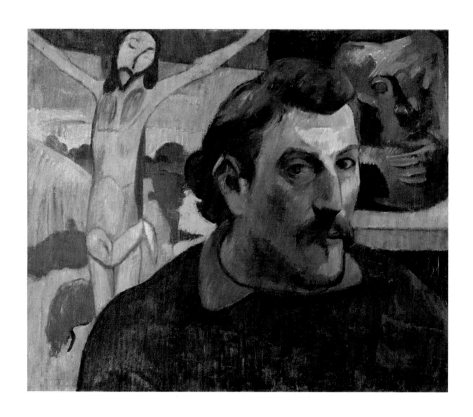

Nonetheless, he soon realized that Paris was not the place in which his art would flourish. He spent most of 1889 in Brittany, with trips to Paris to organize an exhibition of his work and that of his vanguard colleagues, who called themselves Impressionists as well as Synthetists, a new term that suggested the duality of artificiality and poetic and visual synthesis in their work. The show was held at the Café des Arts, also known as the Café Volpini, just outside the fairgrounds of the Exposition Universelle. Paintings by the artist from this period are testaments to the degree to which he felt uneasy in his adopted landscape despite his admiration for it.[10]

The sense of unease — of something lying beneath the apparent subjects of his paintings — had become, and

would remain, the hallmark of Gauguin's art. In his *Land-scape with Two Breton Women*, from the autumn of 1889, he intimated a spiritual dimension in an otherwise quotidian subject, painting the figure at right in such a way as to make the viewer believe that she is praying, although she is actually eating. Earlier, he had painted a powerful scene of women in prayer before a statue of Christ in a landscape—a statue transposed from a chapel wall to this setting in Gauguin's mind, and seemingly coming to life in the imagination of the women confronting it. This work, his famous *Yellow Christ* (1889; Albright-Knox Art Gallery, Buffalo), appears in the background of a subsequent self-portrait that Gauguin almost certainly began in the autumn of 1889 and revisited the following year, when he added to the composition a second self-portrait, a pot sculpted in clay like a primitive totem, that Gauguin described as a "devil all doubled up to endure his pain."[11] Bracketed by

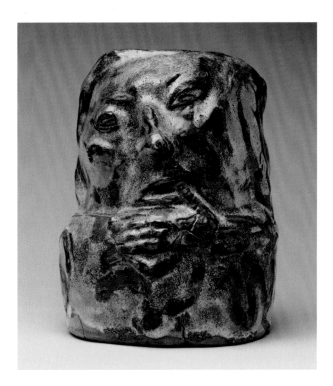

Jar in the Form of a Grotesque Head, 1889

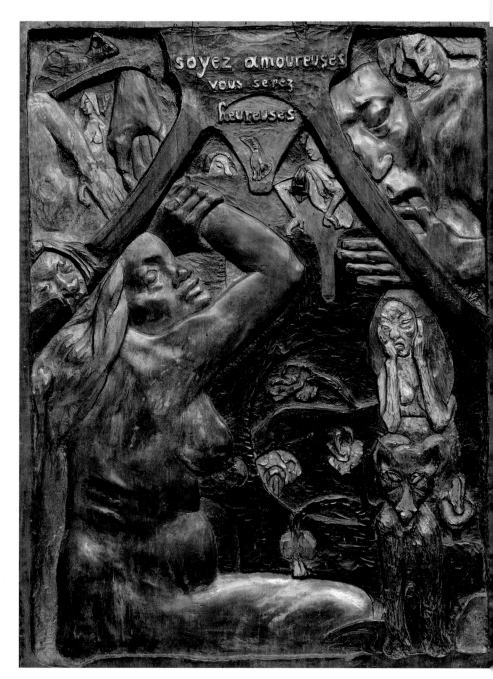

images of piety and suffering, Gauguin stares at the viewer as if to ask: What will become of me?

There is no evidence that Gauguin had yet, in early 1889, seen the Polynesian *tikis* to which the pot bears a striking resemblance, and which he would later evoke in paintings, sculpture, and the graphic arts. Rather, the self-portrait jar is evidence of Gauguin's strong affinity for the grotesque and "primitive"—which could just as easily be encountered in the sculpture or popular art of Brittany or even Japan. It also reveals his predisposition to imbue his works with highly charged, deliberately ambiguous and contradictory forces; here the monstrous head is shown sucking its thumb, in a gesture both calculating and infantile. Gauguin reprised the "devil" self-portrait that same year in his carved masterpiece in wood *Be in Love and You Will Be Happy*. Describing it as "the best and strangest of what I've done in sculpture," the artist sent it on consignment to Theo van Gogh, who was evidently perplexed by it. Gauguin sent Theo an explicit reading of the relief's iconography, but not an explanation of its significance:

At the top the rotting city of Babylon. At the bottom, as though through a window, a view of fields, nature, with its flowers. Simple woman, whom a demon takes by the hand, who struggles despite the good advice of the tempting inscription. A fox (symbol of perversity among Indians). Several figures in this entourage who express the opposite of the advice ("you will be happy") to show that it is fallacious.[12]

Gauguin called Theo's attention to the "fallacious" advice in the sculpture's title, and the modern viewer should heed his suggestion. His repeated mention of the fox, "symbol of perversity among Indians," may be not so much a warning against carnality as a hint of the devious or conflicting intentions that the sculpture embodies.

Be in Love and You Will Be Happy, 1889

Neither the relief nor the ceramic pot is the sensational product of a provocateur, rather they are the workings of a complex intelligence struggling to express issues of Eros and fear.

"You know that I have Indian blood, Inca blood in me, and it's reflected in everything I do," Gauguin wrote to Theo. "It's the basis of my personality; I try to confront rotten civilization with something more natural, based on savagery."[13] The desire to seek a location even more savage than Brittany preoccupied Gauguin at the end of 1889 and through 1890. He sought to separate himself—ostensibly forever—from Paris and the corrupting influences of the world of art he had come to disdain, the tyranny of the official system, certainly, but also the pettiness of even the advanced circles with which he was associated. Casting about for an idea of where he might go next, he researched the far-flung colonies of France, but rejected first one place and then another. It was probably at the display devoted to the French colonies at the 1889 exposition that he first thought of Tahiti, in French Polynesia, as a destination. Little by little his goal became to transfer his life to the island, a place he dreamed of as the land far from Paris in which the poetry of his art could find its most sincere expression.

In September 1890, two months after Van Gogh' death, Gauguin wrote to the artist Odilon Redon, declaring, "I shall go to Tahiti and I hope to end my days there. I judge that my art, which you like, is only a seedling thus far, and out there I hope to cultivate it for my own pleasure in its primitive and savage state. In order to do that I must have peace and quiet. Never mind if other people reap glory! Here, Gauguin is finished, and nothing more will be seen of him."[14] About February 1891 he wrote to his wife in Copenhagen, of his wish to "flee to the woods on a South Sea island, and live there in ecstasy, in peace and for art.

With a new family, far from this European struggle for money. There, in Tahiti, in the silence of the lovely tropical night, I can listen to the sweet murmuring music of my heart, beating in amorous harmony with the mysterious beings of my environment. Free at last, with no money troubles, and able to love, to sing and to die."[15]

His decision to leave behind Paris and the world of art that it represented, ironically, was carried out in public. "I'm leaving so that I can be at peace, so that I can rid myself of the influence of civilization," Gauguin announced to the journalist Jules Huret in February 1891, at the time of the auction sale of his paintings that was to finance his journey. "I want to create only simple art. To do that, I need to immerse myself in virgin nature, to see only savages, to live their life, with no other care than to portray, as would a child, the concepts in my brain using only primitive artistic materials, the only kind that are good and true."[16]

Gauguin's desire to communicate his ideas through primitive, childlike means was no doubt real. But it must be recognized that his public, almost notorious, separation from Paris was a posture. For several years, as he increasingly became sophisticated and adept at managing the vagaries of his own reputation, he had fostered the image of the outsider, the pilgrim of art, by virtue of what he submitted for exhibition in Paris, as well as in Scandinavia and the Low Countries, and through his interviews with the press and the stories about himself that he put into circulation. He became what one critic has called "a veritable professional exile."[17]

The conundrum in his departure for Tahiti rests in the contradiction between Gauguin's stated goal to flee to freedom, to live "in ecstasy, in peace and for art," and his real need to sell works of art to live. How could he go away "to love, to sing and to die" and be "free at last, with no money

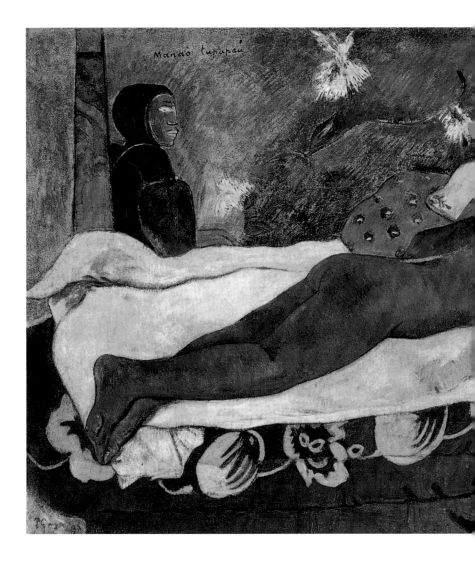

Manao tupapau
(*The Spirit of the Dead
Watching*), 1892

troubles" if "nothing more" were to be seen of him? He had no long-term concrete plans for survival in his imagined Arcadia. But for the short term, Gauguin's strategy for selling his works to fund his travel was a success: For an artist of testy temperament, with a reputation for irascibility, who was far from being at the forefront of the market, the auction result of some 9,600 francs was a decent outcome for the sale of thirty paintings. In late March 1891, a month after the auction, a banquet was held at the Café Voltaire to celebrate Gauguin's departure, attended by more than forty members of the Parisian vanguard. On the first of April, Gauguin sailed from Marseilles to Tahiti, arriving in Papeete, its capital, more than two months later, in early June.

Was Gauguin's proclaimed desire to live and die in Tahiti sincere? At his farewell banquet, his friend the poet Stéphane Mallarmé invited the guests to "drink to the return of Paul Gauguin," as if it were assumed that his departure was for a sojourn, not for a lifetime.[18] For Gauguin to remain a vital artist, complete isolation from his past and from Paris was unthinkable. Yet the two years he spent in Tahiti, from 1891 to 1893, changed his art forever and resulted in the work that, to a later generation, secured the artist's renown. The paintings and sculptures produced during this time, his first of two Tahitian sojourns — the astonishing landscapes of tropical vegetation, the island transpositions of Judeo-Christian iconography, and the languorous images of Tahitian beauties, many of which are profoundly personal ruminations on the character of his lover, Tehamana (for example, *Manao tupapau* [*The Spirit of the Dead Watching*], and *Merahi metua no Tehamana* [*The Ancestors of Tehamana*]) — were superbly realized and deeply felt.[19] It would be unfair to assume that these two years in Tahiti were calculated on market principles, but the fact remains that Gauguin painted for an audience, and there was none

for his work in Polynesia. There was no Arcadia without Athens, no paradise without Paris.

In 1893, then, he returned to Paris, to mount an exhibition of the remarkable works he created in Tahiti (some of which he previously had sent to Mette in Copenhagen, in the futile hope of selling them there). Held at the Galerie Durand-Ruel in November 1893, the exhibition was a mixed success critically and not at all a success financially. Along with a handful of Breton canvases and a number of his "ultra-barbaric" carvings, he showed forty-one paintings from Tahiti.[20] Priced at roughly three times what his paintings had sold for two years before, only eleven pictures found buyers—but among the buyers were people whom Gauguin much admired, notably Edgar Degas. The public in attendance was baffled, but Gauguin put on a brave face. As Morice recalled, "He watched the public, and listened. Soon there could be no doubt: they did not understand. It was the final split between Paris and himself, all his great projects were ruined, and—perhaps the cruelest blow to his proud spirit—he had to admit that he had made his plans poorly. . . . No one can imagine the anguish that tore at his heart . . . [but] he was the Indian who smiled through his torture."[21]

Following the debacle of the exhibition, Gauguin, accompanied by Annah la Javanaise, a thirteen-year-old girl from Ceylon (now Sri Lanka), and her monkey, settled into a very public bohemian existence in Paris, hosting evenings in his studio and participating in the life of the city's advanced artistic circles. This lasted from the late autumn of 1893 until the spring of 1894, when he departed again for Brittany. But even there he was beset by troubles, financially and personally, and in September he announced to his artist friend Georges-Daniel de Monfreid that he had "come to an unalterable decision—to go and live forever in Polynesia."[22] By mid-autumn he was back in Paris. At

Merahi metua no
Tehamana
(The Ancestors of
Tehamana), 1893

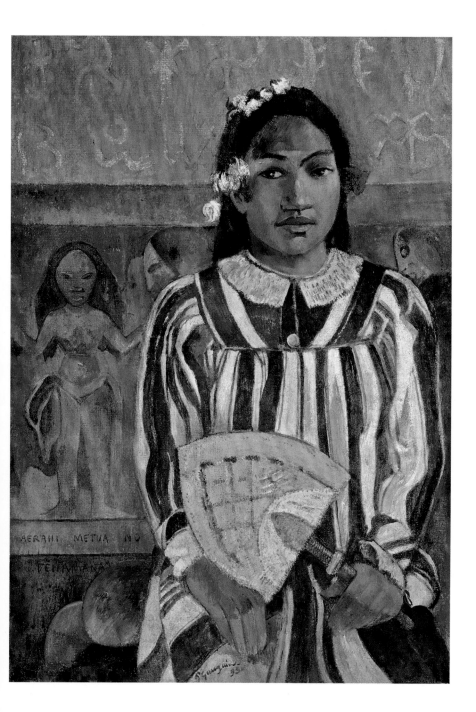

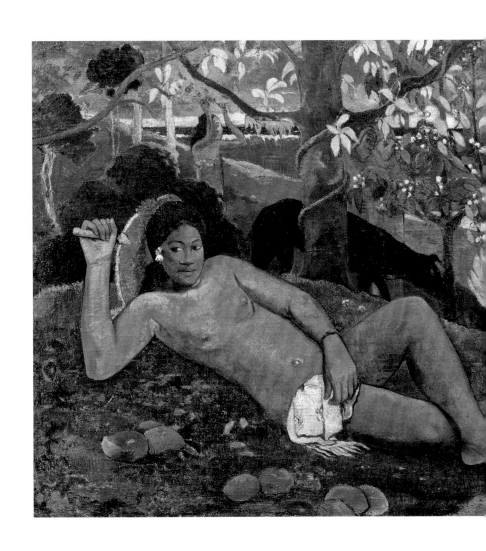

Te arii vahine

(*The Noble Woman*),

1896

a banquet at the Café Escoffier in December he publicly announced his intention of returning to the South Seas. "Paul Gauguin had to choose between the savages here or the ones over there," announced the *Journal des artistes*. "Without a moment's hesitation, he will leave for Tahiti."[23]

Although he did not depart until July 1895, more than six months later, he never would return to Paris. The rest of Gauguin's career was spent in the South Pacific, first in Tahiti, from late 1895, then in the Marquesas Islands, from 1901 until his death in May 1903. Yet, although he had left Paris behind, he never was able to free himself completely from its influence. First, in Papeete he had to deal with the French: officials of the colonial government, who sometimes employed Gauguin when he needed funds, or colonists, who might offer the soon-beleaguered artist occasional work — as a drawing instructor, for instance. In addition, painting supplies had to come from France and were long in arriving: Indeed, anything shipped from Paris, a package or a letter, would take two months to reach him at his South Seas home. Gauguin had to send paintings to Paris for sale, so that he might have money to live on, and he waited impatiently not only for income but also for praise.

It is clear that between the time of his arrival in Papeete in early September 1895 and the beginning of 1896, Gauguin made hardly any art. "I've not yet touched a brush except to make a stained glass window for my studio," he wrote to Monfreid in November (referring to his habit of painting images on glazed windows or doors).[24] In the first months of the new year, however, he experienced a remarkable burst of creative energy. By April, he had finished an extremely ambitious canvas, *Te arii vahine* (*The Noble Woman*), the first masterwork of his second trip to Tahiti.[25] Oddly enough, the composition was based on a wooden relief that he had carved in oak at the end of 1889,

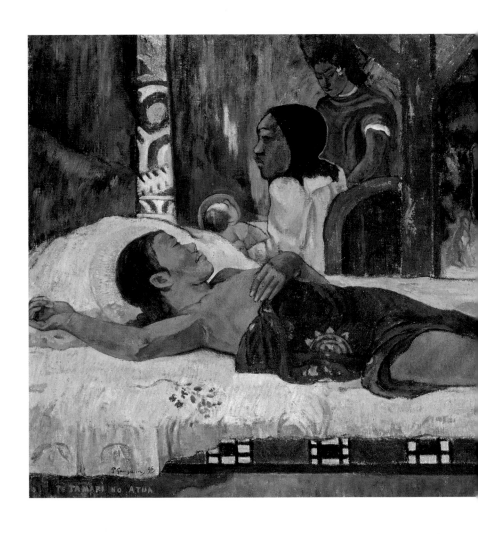

Te tamari no atua
(*The Child of God*), 1896

Reclining Woman in a Landscape, which was in turn inspired by a Renaissance painting of Diana resting in a landscape by the German master Lucas Cranach.[26] He described it to Monfreid as "A naked queen, reclining on a carpet of green, a female servant gathering fruit, two old men, near the big tree, discussing the tree of knowledge; a shore in the background . . . I think that I have never made anything of such deep sonorous colors."[27] There are many possible associations between Gauguin's great nude and the European art of the past — not only Cranach's Diana, but the Venuses of Titian and their contemporary descendant, Manet's *Olympia*, of which Gauguin had executed an ambitious copy just five years earlier.[28] In the painter's reference to the tree of knowledge, and in the serpentine vine encircling the trunk of the tree, there are intimations of good and evil that place his captivating nude in a biblical frame of reference that any Western viewer would have recognized.

That blending of Tahitian models and Judeo-Christian tradition lies at the heart of the painting that has been described as a pendant to *Te arii vahine: Te tamari no atua* (*The Child of God*). The sleeping woman, wrapped in a blue pareu, reclines on an exotic bed, draped in bright yellow sheets. A still more intense shade of yellow is used to indicate a halo around the woman's head, roughly echoing the position of the scarlet fan held by Gauguin's "great queen." The painted post behind and above the woman's head is strikingly similar to the post behind Tehamana's bed in *Manao tupapau* (see page 18).[29]

Over the course of the second half of 1897, Gauguin sank into one of the most depressive periods of his career. Deeply unhappy, sick of body and mind, he felt sure that he soon would die. Nonetheless, he was writing furiously, resulting in a manuscript of ruminations on art-making and its formal principles, and its poetic goals, which he titled "Diverses choses" ("Miscellaneous Things"). Con-

cerned with issues of pictorial strategy, but fundamentally a study of the power of color and its ability to convey emotion, the text is filled with commentary on his own principles and on his appreciation of the contributions of artists from the past, from Raphael to Eugène Delacroix. His manuscript reveals that the worlds of art and literature were ever present in Gauguin's mind. Far from having left Europe behind in Polynesia, he seemed, in the solitude of his hut in Tahiti, to have come to understand the world he had left behind more fully and on his own particular terms. Through days and nights he pored over his collection of hundreds of prints and photographs—his traveling museum of reproductions of the art of the past, documenting everything from the reliefs and statues of the ninth-century Buddhist temple of Borobudur in Indonesia to the paintings of the fifteenth-century Florentine artist Sandro Botticelli—or over books that he had brought with him from home, obtained in Polynesia, or had memorized. This absorption in the product of the world he abandoned for a new existence fueled his thinking, shaping his ideas as he set down his feelings in words.

His first concern was color, "the language of the listening eye . . . suited to help our imaginations soar, decorating our dream, opening a new door onto mystery and the infinite."[30] "Color," he wrote, "being enigmatic in itself, as to the sensations it gives us, then to be logical we cannot use it any other way than enigmatically every time we use it, not to draw with," as great masters of color such as Delacroix had done, "but rather to give the musical sensations that flow from it, from its own nature, from its internal, mysterious, enigmatic power," much as Beethoven had done. Gauguin's writing became still more abstract in his attempt to describe the ability of his strain of visual Symbolism to unite the senses in appreciation of a work of art. "Color which, like music, is a matter of vibrations,"

he said, "reaches what is most general and therefore most undefinable in nature."

In a separate section of "Diverses choses," he addressed issues of religious thought, revealing his idea that in modern times humankind should transcend the traditional boundaries and limitations of outmoded religion, to bring belief systems "together in one philosophical comprehension, merge them, identify them in a single, revitalized whole, richer and more fertile" than before.[31] He began his disquisition on religion with the great riddle, "Where do we come from? What are we? Where are we going? What is our ideal, natural, rational destiny?"

In painting, by extension, Gauguin argued that it would be impossible for the aesthetic problem he posed to "be solved by a mathematical equation or explained by literary means."[32] Rather, it could be solved only pictorially, for "of all the arts, painting is the one which will smooth the way by resolving the paradox between the world of feeling and the world of intellect. Has this movement of painting through color been glimpsed, put into practice by someone? I will not draw any conclusions, nor name anyone. That is up to posterity," he concluded, in a scarcely veiled reference to his own ambition.

By the end of 1897 Gauguin's long-envisioned project for a great painting, the program for which he had outlined in "Diverse choses," was well under way.[33] It was his desire to make a painting that, true to his ideas, transcended the obsolete boundaries of conventional representation to unite the great traditions of French art: the rigorously intellectual classicism epitomized by Nicolas Poussin and the ineffable, indefinable colorism represented by Delacroix. This work, of course, is, Gauguin's masterpiece, *Where Do We Come From? What Are We? Where Are We Going?* (D'où venons-nous? Que sommes-nous? Où allons-nous?) of 1897–98 (see following p. 32).

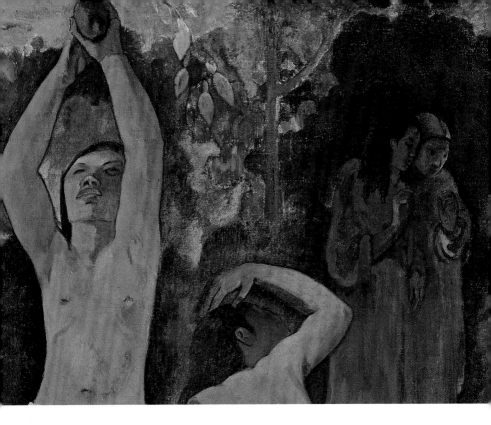

The largest painting Gauguin ever attempted, it measures more than thirteen feet in width. It is painted on a burlap support over a roughly applied ground, first sketched in blue, then worked up in rich passages of color, densely or thinly applied. Working with care but with evident speed, Gauguin created a magnificent, profoundly moving panoply of human life, set in a landscape at once brooding and joyous. At the upper left, on a field of yellow gold, he inscribed the questions that serve as the painting's title.

Gauguin claimed that he finished the painting in January 1898. Although none of the letters he wrote at the end of 1897 mentions the canvas being in progress, he must have worked on it over several weeks, if not months. He wrote to Monfreid about the painting in February 1898; if

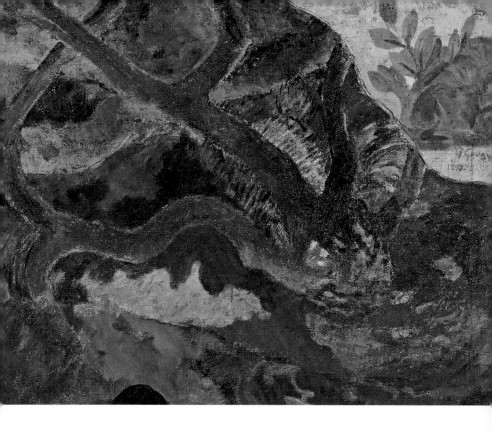

his account of what happened is faithful, upon completing the picture he went up into the hills, armed with poison, to take his own life. He did not succeed, either because he took too little of the arsenic he claimed to have used, or too much for his body to hold down. After what he described to Monfreid as "a night of terrible suffering," he returned to his home.[34] In the letter, he went on to include his first transcription of the painting into words, still the most immediate explanation of its origins and meaning:

Before I died I wished to paint a large canvas that I had in mind, and I worked day and night that whole month in an incredible fever. Good God, it's not a canvas done like a Puvis de Chavannes, with a drawing from life, a preparatory cartoon,

etc. It's all straight from the tip of the paintbrush on sackcloth full of knots and wrinkles, so the appearance is terribly rough.

They will say that it is careless, unfinished. It's true that it's not easy to judge one's own work, but in spite of that I believe that this canvas not only surpasses all my preceding ones, but that I shall never do anything better, or even like it. Before death I put into it all my energy, a passion so painful in circumstances so terrible, and my vision was so clear that all haste of execution vanishes and life surges up. It doesn't stink of models, of technique, or of pretended rules — of which I have always fought shy, though sometimes with fear.

It is a canvas four meters fifty in width, by one meter seventy in height. The two upper corners are chrome yellow; with an inscription on the left and my name on the right, like a fresco whose corners are spoiled with age, and which is attached to a golden wall.

The composition consists of twelve figures disposed against the lush landscape of Tahiti. In his letter to Monfreid, Gauguin included a rough sketch of the painting, and was at pains to describe and to elucidate the characters one by one, moving from right to left. "To the right, at the lower end," he wrote, are "a sleeping child and three crouching women," whose poses recall the groups of women and children that had peopled his canvases from 1891 to 1893.[35] Beyond them, to the left and shown as if emerging from a cloud, "two figures dressed in purple confide their thoughts to one another," flanked by "an enormous crouching figure, out of all proportion, and intentionally so," who "raises its arm and stares in astonishment upon these two, who dare to think of their destiny." Moving to the left, "a figure in the center is picking fruit." Gauguin next mentioned, again to the left, "two cats near a child. A white goat. An idol, its arms mysteriously raised in a sort of rhythm, seems to indicate the Beyond . . . then lastly,

Illustrated letter to
Daniel de Monfreid,
February 1898

Février 1898 -

Mon cher Daniel.

Je ne vous ai pas écrit le mois dernier, je n'avais plus rien à vous
dire sinon répéter, puis ensuite je n'en avais pas le courage.
Aussitôt le courrier arrivé, n'ayant rien reçu de Chaudet, ma
santé tout à coup presque rétablie c'est à dire sans plus de chance
de mourir naturellement j'ai voulu me tuer. Je suis parti me
me cacher dans la montagne où mon cadavre aurait été dévoré
par les fourmis. Je n'avais pas de révolver mais j'avais de
l'arsenic que j'avais thésaurisé durant ma maladie d'eczéma:
est ce la dose qui était trop forte, ou bien le fait des vomissements
qui ont annulé l'action du poison en le rejetant, je ne sais.
Enfin après une nuit de terribles souffrances je suis rentré
au logis. Durant tout ce mois j'ai été tracassé par des pressions
aux tempes, puis des étourdissements, des nausées à mes repas
minimes. Je reçois ce mois-ci 700f de Chaudet et 150f de
Mauffra : avec cela je paye les créanciers les plus acharnés, et
recontinue à vivre comme avant, de misères et de honte jusqu'au
mois de Mai où la banque me fera saisir et vendre à
vil prix ce que je possède entre autres mes tableaux. Enfin nous
verrons à cette époque à recommencer d'une autre façon.
Il faut vous dire que ma résolution était bien prise pour
le mois de Décembre alors j'ai voulu avant de mourir peindre
une grande toile que j'avais en tête et durant tout le
mois j'ai travaillé jour et nuit dans une fièvre inouie.
Dame ce n'est pas une toile faite comme un Puvis de Chavannes,
études d'après nature, puis carton préparatoire etc. Tout
cela est fait de chic au bout de la brosse, sur une toile
à sac pleine de nœuds et rugosités aussi l'aspect en est terriblement
fruste. On dira que c'est lâché etc.....

+ D'où venons nous ?
Que sommes nous
Où allons nous

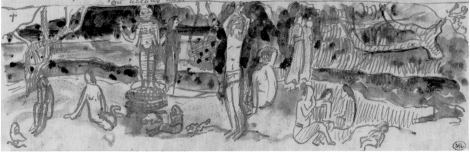

an old woman nearing death." This woman, in the artist's
words, "appears to accept everything, to resign herself to
her thoughts. She completes the story! At her feet a strange
white bird, holding a lizard in its claws." The painter inex-
plicably omitted from his description the languid beauty
who sits, literally and figuratively, between the old woman
and the child eating a fruit.

Gauguin told Monfreid that the setting for the painting
was "the bank of a river in the woods. In the background the
ocean, then the mountains of a neighboring island. Despite
changes of tone, the coloring of the landscape is constant,
either blue or Veronese green." The scenery is, in fact, a
remarkable combination of the real and the imagined. In
the upper left a distant view of the neighboring island of
Moorea, drenched in sunlight, frames the statue of the
moon goddess Hina, a wholly fictional sculpture based on
Asian prototypes. In the upper right the river rises from
the earth among the roots of purau trees, whose branches,
interlacing and repeating across the upper register of the
canvas, provide a rhythmic parallel to the movement of the
water from right to left. The ground, cast into deep shadow
or brilliantly illuminated — as in the pink passages at far
left — often is painted quite delicately, pigments placed
beside and over one another in sensuous, vaporous layers.

True to his habits, Gauguin had rifled his "museum"
of reproductions to find ideas for the figural poses. The
women at right who gaze quizzically at the viewer were lifted
almost whole from Borobudur carvings. Gauguin had seen
a cast of the temple at the Exposition Universelle in Paris in
1889, and had procured photographs of some of its reliefs,
which proved endless sources of inspiration to him. The
central figure, a kind of Polynesian Adam, derives from a
sculpted bodhisattva in one of the Borobudur photographs,
together with the pose of a male nude from a drawing in the
Louvre in Paris, which in Gauguin's time was thought to be

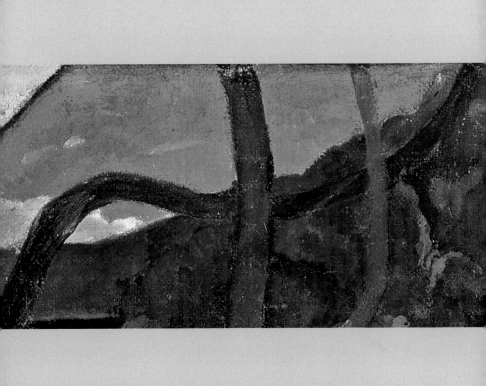

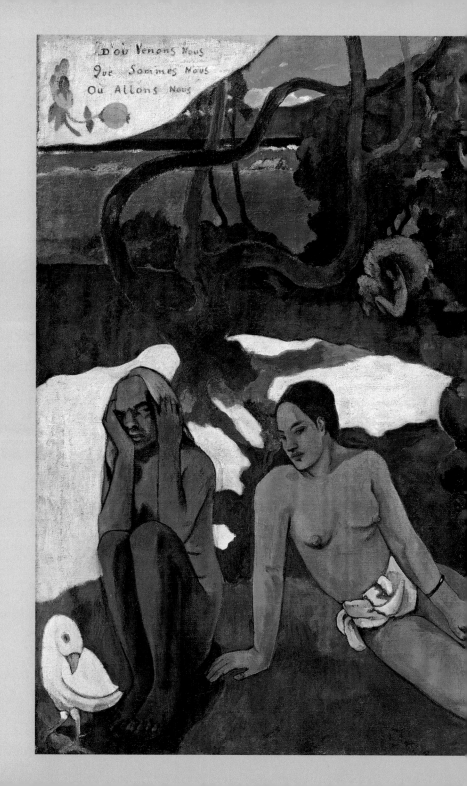

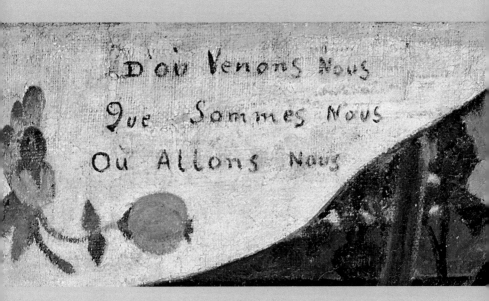

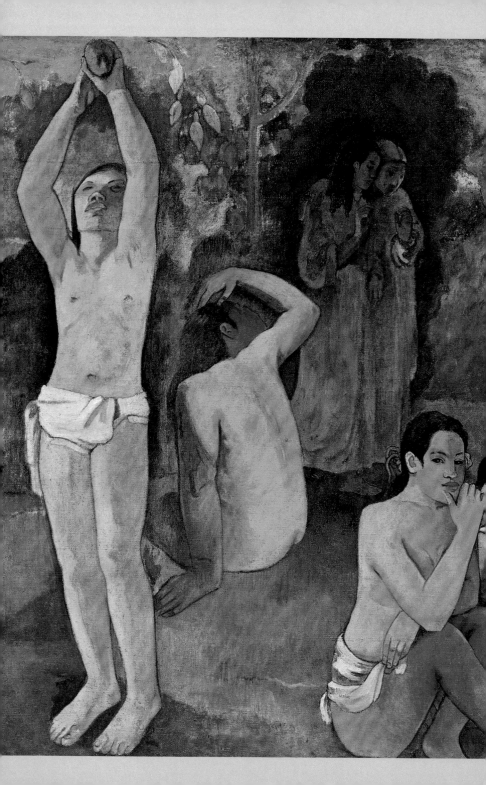

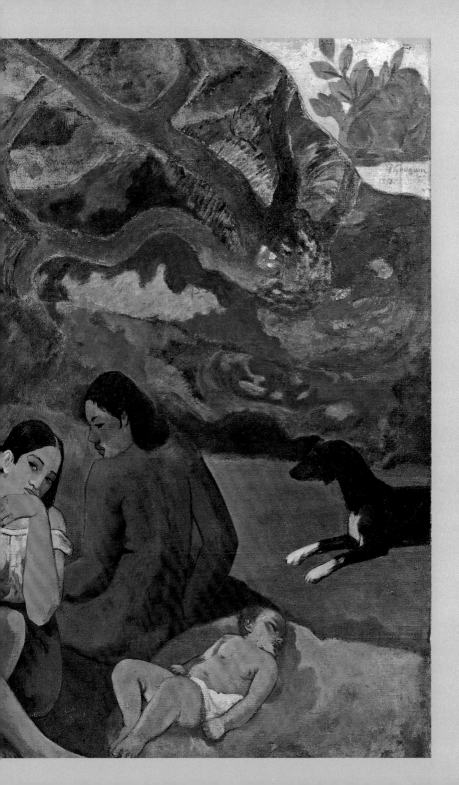

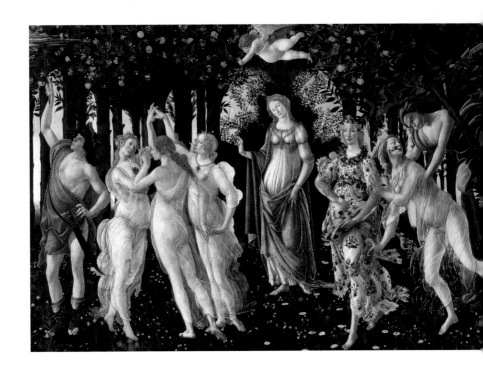

Botticelli, *Allegory of Spring* (*La Primavera*), about 1481

by Rembrandt.[36] From memory or from earlier drawings that he kept with him, Gauguin painted the "old woman nearing death," whose infolded pose comes from that of a mummified corpse from Peru that Gauguin had seen at the Musée de l'Homme in Paris—a figure that first appears in his art in the 1880s and stayed in his imagination, through multiple transmutations, for the rest of his life.[37]

For Gauguin, *Where Do We Come From?* was, self-consciously, a masterpiece. It was meant to be his testament, a summation of his achievements and the conclusion—in logic, as well as in fact, had his suicide taken place—of his aesthetic, philosophical, and poetic career. It was also a translation into Gauguin's pictorial language of quotations from the history of art. Its sources are many and varied. Individual figures might be traced, as suggested above, to Buddhist carvings, works by Rembrandt, or arti-

facts from anthropology museums. Botticelli's famous *Allegory of Spring (La Primavera;* about 1481), in which figures are arrayed against a grove of trees, probably was a source for the compositional structure of *Where Do We Come From?* as well as for that of Gauguin's earlier painting of paradisial pleasure *Nave nave mahana (Delightful Day).*

The curious independence of Gauguin's figures may be an echo of Botticelli's enigmatic allegory, in which the participants, on the whole, seem to be unaware of one another. Their organization in a stately frieze, however, represents one of the great visual traditions of French art, ever present from the portals of Gothic cathedrals to the hieratic compositions of Jacques-Louis David and Jean-Auguste-Dominique Ingres. It should thus come as no surprise that another source of Gauguin's inspiration must have been found in the work of Poussin, France's

greatest classicist, whose ability to group figures in stately progressions within landscape settings and to orchestrate pictorial movement among figures is unrivaled. Specifically, both the details and the overall arrangement of *Where Do We Come From?* display a striking resemblance to one of Poussin's masterpieces, *The Realm of Flora*, painted in 1631 in Rome.[38] Poussin's painting shows a group of figures — mortals beloved of the gods, whom, according to Ovid, love transformed into flowers. The landscapes of the two paintings bear comparison, each with contrasting zones of dark and light, flowing water, and the presence of a statue at left. Among the figures, the woman at far right in *Where Do We Come From?* echoes the nymph holding a vase in the foreground of *Flora*; Gauguin's seated figure who stares at the pair of shadowy wanderers suggests Poussin's figure of Clytie, who shields her face with her hand as she gazes in astonishment at Apollo in his chariot; and even the figure of "Adam" in Gauguin's masterpiece recalls the naked figure of Hyacinth in Poussin's picture, who stands with his arm encircling his head. Gauguin probably owned a photograph of the painting.[39]

Where Do We Come From? was not, however, merely a modernization or a personalization of a classical French prototype. Gauguin took care to distance his work, whenever he subsequently described it, from the tradition of allegory that stretched back to Poussin and that Pierre Puvis de Chavannes represented most conspicuously, in works such as *Inter Artes et Naturam* (1890), which had been exhibited at the Salon of 1890. In a February 1898 letter to Monfreid, Gauguin was keen to reject such comparisons. After *Where Do We Come From?* had been shown in Paris, in 1899 Gauguin wrote to the critic André Fontainas, who had complained that "there is nothing [in the work] that reveals to us the meaning of the allegory."[40] "Well," Gauguin replied to Fontainas, "my dream cannot be appre-

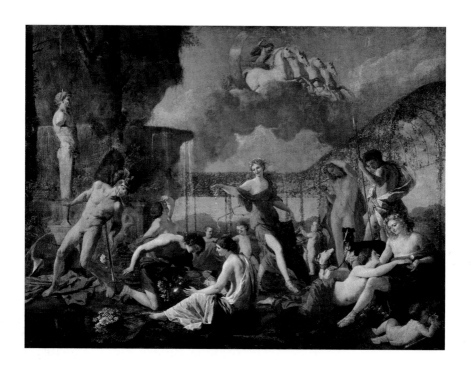

hended, it requires no allegory; being a musical poem, it needs no libretto," calling to his aid the poet Mallarmé's dictum that "the essential quality of a work consists precisely in what is not expressed."[41]

Despite the fact that he decoded the painting to more than one correspondent, to Monfreid in 1898 and Morice in 1901 — perhaps so that it could be elucidated further to a future critic or to a prospective buyer — Gauguin did not intend *Where Do We Come From?* to be read bit by bit, as a compendium of symbols with a cumulative meaning or allegorical unity. Instead, he told his friends, as well as his critics, that the painting was not, "like those of Puvis de Chavannes," the sort of work that "originated from an idea, *a priori*, abstract, which I sought to vivify by plastic representation."[42] When in 1901 he wrote about the painting to Morice, he gave a close reading of its components, but

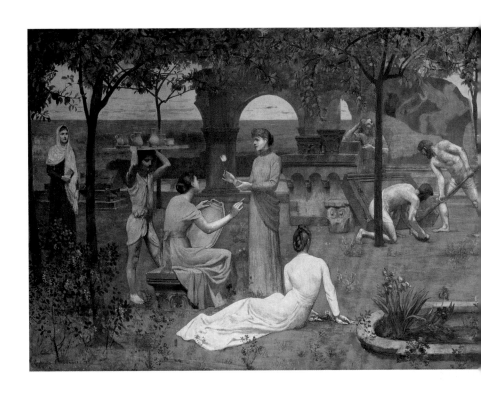

he insisted that "explanatory attributes—known symbols—would congeal the canvas into a melancholy reality, and the problem indicated would no longer be a poem."[43] The painting, as Gauguin desired it, remains deliberately enigmatic.

Still, there can be no doubt that Gauguin himself understood his painting in the context of mural decoration of the past and the present. The critic Albert Aurier had once compared his compositions to "fragments of immense frescos," and it was perhaps in memory of this that the painter likened his canvas to "a fresco whose corners are spoiled with age . . . attached to a golden wall," suggesting that it could be interpreted both as a recovered relic and a decoration in current use. Although he downplayed the painting's relationship to the murals of Puvis on the grounds of procedure and intention, in

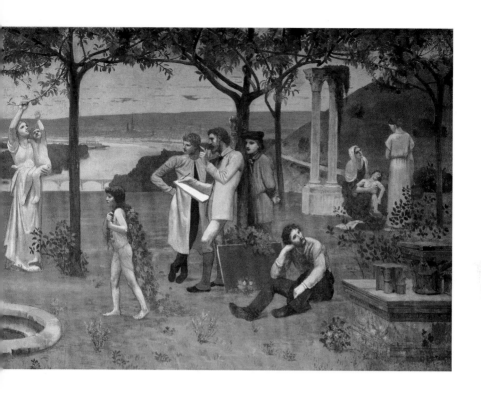

formal terms he cannot have hoped that his figured land-
scape—for all its apparent rejection of classical formulas
and execution—could escape comparison with the time-
less groves that Puvis had popularized in murals for the
museums in Lyon and Rouen, as well as the great hemcycle
of the Sorbonne.[44]

Within Gauguin's circle, *Where Do We Come From?* would
have been seen in the context of decorative paintings by his
former comrade Paul Sérusier and his Nabi followers Mau-
rice Denis, Edouard Vuillard, and Pierre Bonnard. Out-
side the artist's immediate circle, the Arcadian themes of
Gauguin's great painting linked it to *In the Time of Harmony*,
the recently completed mural by Paul Signac.[45] But the
vanguard viewer of *Where Do We Come From?* in 1898 would
have recognized it as a retrospective challenge to the mag-

num opus of the late Georges Seurat, whose *Sunday on La Grande Jatte* (1884–86) depicted, in a riverside landscape, beneath the shadows of trees, men, women, children, and animals under curving branches, in shadow and in light. That canvas, in a radical, Neo-Impressionist technique, and executed on a scale and with an ambition that Gauguin could not yet attempt, was first shown at the last Impressionist exhibition in 1886 — where Gauguin himself had been represented by a series of relatively conservative landscapes and figure paintings that revealed his continuing debt to Pissarro and Armand Guillaumin.[46] Although Gauguin had soon left this timid Impressionist manner behind, it was not until a decade later, in *Where Do We Come From?* that he would create a work whose scale would rival that of Seurat's monumental canvas.

By rights Gauguin painted *Where Do We Come From?* as a statement of his deepest convictions. Its title posed a series of unanswerable questions, questions that were meant to perplex the viewer and to make the experience of seeing the picture a memorably troubling one. But the painting is also a declaration of Gauguin's power and ambition. This decree was made, inescapably, to an audience half a world away: a shout of anguish, perhaps, but also of glory, from paradise to Paris.

The story of what happened to *Where Do We Come From?* after its completion makes this clear. Probably in January 1898, as he was finishing the large painting, he set to work on an ancillary series of smaller canvases of identical size, each an extract or echo of motifs found in the larger panel, executed in a range of colors intended to complement the principal work.[47] By July 1898, six months after he attempted suicide, he had finished the group. He then sent them, along with his masterwork, to Monfreid, with the explicit goal of presenting, as well as selling, his paintings to a Parisian audience.

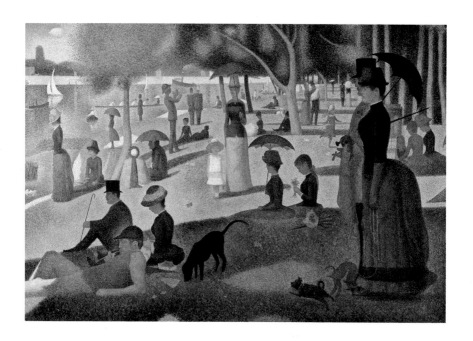

At the earliest Gauguin could have anticipated a reaction to the shipment by the end of the year. He longed desperately to receive news of the pictures' fate — "waiting impatiently for the next mail," he wrote, "in a hurry to know whether I am wrong or not."[48] In the end he did not learn until early 1899, in a letter from his friend Georges Chaudet, that the paintings had been exhibited at the Galerie Ambroise Vollard to considerable success among avant-garde critics.[49] As he received the reviews, he disputed their assertions, argued with their conclusions, or thanked those critics who had been his supporters. The masterpiece had had its effect.

While he received letters from his friends associated with the exhibition, and while he read in the press echoes of his masterpiece's reception, there is only circumstantial evidence of other artists' reactions to it. The artists who had dealings with Vollard are likely to have seen it, of course.

They include Gauguin's mentor Degas, whom the dealer had been courting, and the great Cézanne, who from January 1898 to 1899 rented a studio in Paris in the Villa des Arts, during which time he painted Vollard's portrait. Until 1901, in fact, the canvas remained with Vollard, and thus it could be — and almost certainly was — seen by the younger artists who interacted with the gallery: the Nabi painters Pierre Bonnard, Maurice Denis, and Édouard Vuillard, all of whom Vollard promoted as printmakers; Henri Matisse, who in 1899 traded Vollard work of his own for a picture by Gauguin; and Pablo Picasso, whose first Paris exhibition was held at Vollard's gallery in 1900.[50]

In the two years following the exhibition, although Gauguin continued to paint major canvases, the fate of *Where Do We Come From?* preoccupied him. In a May 1901 letter to Gauguin, Morice proposed offering the painting to the French nation, for the Musée du Luxembourg in Paris, the state's official museum of contemporary art. "Degas, Redon, Dolent, Rouart, more and still more will contribute," Morice suggested, naming artists and collectors who might donate funds toward its purchase. "Needless to say," he went on, "the Luxembourg will refuse. But it would be a chance to publicize your name."[51] Upon receiving the letter in July, Gauguin leapt at the suggestion, writing immediately to Monfreid with a list of potential subscribers to the campaign and addressing a lengthy letter to Morice (the letter in which, as discussed above, he explained the painting without, he said, wanting to explain it).[52]

By this time, it had been three years since Gauguin had shipped the painting to Paris, and thus just as long since he last had seen it. While he may have had a drawing or photograph of the picture to remind him of its details, he wrote to Morice about it with fluency, as if he were standing before it. He could catalogue its elements and explain their function to his friend, but its meaning? That was meant

to be obscure. The memory of the painting, its rumination on the eternal themes of life, and its profound association with death—his own, perhaps—acted on Gauguin like a *tupapau*, a native spirit watching the living, haunting and powerful. "But for the public," Gauguin asked, "why should my brush, free from all constraint, be obliged to open everybody's eyes?[53] To Paris—to the likes of Cézanne and Matisse—went the painting, imbued with its own "internal, mysterious, enigmatic power." It brought with its question a message: I, Paul Gauguin, am here in Paradise. Look upon this, and listen for the music of my heart.

(detail)

NOTES

1. Gauguin to Georges-Daniel de Monfreid, Nov. 1897, in *Gauguin's Letters from the South Seas*, trans. Ruth Pielkovo (New York: Dover, 1992), p. 57. All subsequent citations to correspondence between Gauguin and Monfreid are to this volume. It was first published in 1923 by W. Heinemann as *The Letters of Paul Gauguin to Georges Daniel de Monfreid*.

2. Gauguin's *Bust of Emile Gauguin, the Artist's Son* (1877–78; Metropolitan Museum of Art, New York) was exhibited *hors catalogue*. See Ruth Berson, ed., *The New Painting: Impressionism, 1874–1886* (San Francisco: Fine Arts Museums of San Francisco, 1996), vol. 1, pp. 113, 132. For a broader discussion of Gauguin's Impressionism, see Richard R. Brettell and Anne-Birgitte Fonsmark, *Gauguin and Impressionism*, exh. cat. (New Haven: Yale University Press, 2005).

3. Gauguin, "Notes synthétiques" (1885), trans. and quoted in *Gauguin by Himself*, ed. Belinda Thomson (Boston: Little, Brown), p. 33.

4. Gauguin to Pissarro, late May 1885, trans. and quoted in Charles F. Stuckey, "The Impressionist Years," in *The Art of Paul Gauguin*, by Richard R. Brettell et al., exh. cat. (Washington, D.C.: National Gallery of Art, 1988), p. 15.

5. Gauguin to Schuffenecker, late February 1888, in *The Writings of a Savage*, ed. Daniel Guérin, trans. Eleanor Levieux (New York: Viking, 1978), p. 23 (translation modified).

6. Gauguin to Schuffenecker, early July 1887, in *Correspondance de Paul Gauguin, documents, témoignages*, ed. Victor Merlhès (Paris: Fondation Singer-Polignac, 1984), pp. 156–57 (my translation).

7. Octave Mirbeau, "Paul Gauguin," *L'écho de Paris*, February 16, 1891, trans. and quoted in Daniel Wildenstein, *Gauguin: A Savage in the Making; Catalogue Raisonné of the Paintings, 1873–1888* (Milan: Skira, 2002), vol. 2, p. 333.

8. Van Gogh fantasized that Arles would be like the Japan of his imagination, with the atmosphere and light that he had admired in Japanese prints.

9. For the best account of Gauguin and Van Gogh in Arles, see Douglas W. Druick and Peter Kort Zegers, *Van Gogh and Gauguin: The Studio of the South*, exh. cat. (Chicago: Art Institute of Chicago, 2001).

10. See, for example, *Bonjour, Monsieur Gauguin* (1889), Národni Galerie, Prague.

11. Gauguin, quoted in Cachin, catalogue entry in Brettell et al., *Art of Paul Gauguin*, p. 128, cat. 65.

12. Gauguin to Theo van Gogh, Nov. 20 or 21, 1889, quoted in Marla Prather and Charles F. Stuckey, eds., *Gauguin: A Retrospective* (New York: Hugh Lauter Levin Associates, 1987), p. 108. Many authors have attempted

nonetheless to interpret the sculpture's iconography, chief among them Christopher Gray, *Sculpture and Ceramics of Paul Gauguin* (Baltimore: Johns Hopkins University Press, 1980), 42–48; Wayne Andersen, "Gauguin and a Peruvian Mummy," *Burlington Magazine*, vol. 109, no. 769 (April 1967): 238–42, and *Gauguin's Paradise Lost* (New York: Viking, 1971), 112–16; Anne Pingeot in *Le corps en morceaux*, exh. cat. (Paris: Musée d'Orsay, 1990), 221–22; and June Hargrove in Andrea Blühm et al., *The Colour of Sculpture, 1840–1910* (Zwolle: Waanders, 1996), 110–13.

13. Gauguin to Theo van Gogh, Nov. 20 or 21, 1889, trans. and quoted in Thomson, *Gauguin by Himself*, p. 111.

14. Gauguin to Redon, September 1890, quoted in Guérin and Levieux, *Writings of a Savage*, p. 44.

15. Gauguin to Mette Gad, in *Paul Gauguin: Letters to His Wife and Friends*, ed. Maurice Malingue, trans. Henry J. Stenning (Cleveland: World, 1949), p. 137, no. 100.

16. Gauguin, quoted in Huret, "Paul Gauguin devant ses tableaux," *L'écho de Paris*, February 23, 1891 (my translation).

17. "Gauguin was one of the first artists of the Parisian avant-garde to exploit, systematically and logically, the adage that 'no man is a prophet in his own country.' He saw, better than others, how to gamble on the logics of separation that obtained in the modern art market. An artist who could prove that he had been welcomed abroad would be still better placed on his home turf. So Gauguin became a veritable professional exile: his canvases flung far and wide, himself an exile in his own art, referring incessantly to an 'elsewhere.' Thus, essentially, was constructed his own myth." Béatrice Joyeux-Prunel, "'Les bons vents viennent de l'étranger': La fabrication internationale de la gloire de Gauguin," *Revue d'histoire moderne et contemporaine*, vol. 52, no. 2 (April–June 2005), p. 118 (my translation).

18. Mallarmé, quoted in *Correspondance, 1862–1898*, ed. Henri Mondor (Paris: Gallimard, 1973), vol. 4, pt. 1, p. 211n3.

19. For an in-depth exploration of Gauguin's work from his first trip to Tahiti, see "The First Polynesian Sojourn: June 1891–June 1893," in George T. M. Shackelford and Claire Frèches-Thory, *Gauguin Tahiti*, exh. cat. (Boston: MFA Publications, 2004).

20. "In my two years' stay, some months of which went for nothing, I have turned out sixty-six canvases of varying quality and some ultra-barbaric sculpture." Gauguin to Monfreid, [April–May?] 1893, p. 36. This letter was redated to late March 1893 in Richard S. Field, *Paul Gauguin: The Paintings of the First Voyage to Tahiti* (New York: Garland, 1977), p. 367. For more on the

sculpture Gauguin created during his first trip to Tahiti, see Anne Pingeot, "Sculpture of the First Voyage," in Shackelford and Frèches-Thory, *Gauguin Tahiti*, pp. 68–79.

21. Morice, *Paul Gauguin*, new ed. (Paris: H. Floury, 1920), p. 31.

22. Gauguin to Monfreid, [October–November 1894], p. 36. For the date of this letter, I have followed Jean Loize, who redated it to September 20, 1894. See Loize, *Les amitiés du peintre* Georges-Daniel *de Monfreid et ses reliques de Gauguin: De Maillol et Codet à Segalen*, exh. cat. ([Paris?]: J. Loize, 1951), p. 20.

23. *Journal des artistes*, December 16, 1894, trans. and quoted in Brettell et al., *Art of Paul Gauguin*, p. 294.

24. Gauguin to Monfreid, Nov. 1895, p. 37.

25. See Douglas W. Druick and Peter Kort Zegers, *Van Gogh and Gauguin: The Studio of the South* (Chicago: Art Institute, 2001), pp. 334–35.

26. Ibid., p. 329. See also Naomi E. Maurer, *The Pursuit of Spiritual Wisdom: The Thought and Art of Vincent van Gogh and Paul Gauguin* (Madison, N.J.: Fairleigh Dickinson University Press, 1998), p. 164.

27. Gauguin to Monfreid, April 1896, quoted in Brettell et al., *Art of Paul Gauguin*, p. 398 (translation revised). The painting, in fact, measures 97 x 130 cm (about 37 x 50 in.), which is the standard measurement of a French size 60 canvas (for figure paintings, as opposed to landscape or seascape compositions, for which the format is different). Gauguin's reports of the measurements of his canvases are not always accurate to the centimeter, but it is equally possible that upon its arrival in France the meter-high painting (like the other size 60 canvases that followed it) was simply applied to a standard 97-centimeter stretcher. More likely, however, is Gauguin's possession of at least one standard-size stretcher on which he executed successive paintings, each canvas removed from the stretcher as it was finished and replaced by another support.

28. Gauguin's copy of Manet's *Olympia* is in a private collection. See Brettell et al., *Art of Paul Gauguin*, no. 117, pp. 202–3.

29. See ibid., pp. 409–10. The manger scene in the background at right is a transposition of a painting by Octave Tassaert, once owned by Gauguin's guardian Gustave Arosa; the group at left became the focus of another, smaller, painting by Gauguin, titled *Bé Bé* (W 540; St. Petersburg, State Hermitage Museum).

30. All quotations in this paragraph are from Gauguin, "Miscellaneous Things," in Guérin and Levieux, *Writings of a Savage*, pp. 145–47.

31. Ibid., pp. 166–67.

32. Ibid., p. 147.

33. See ibid., pp. 134–35.

34. This and the following comments to Monfreid are from Gauguin to Monfreid, February 1898, pp. 59–63 (translation modified).

35. See, for example, Gauguin's *Women of Tahiti* of 1891 (Musée d'Orsay, Paris) and *What! Are You Jealous? (Aha oe feii?)* of 1892 (State Pushkin Museum of Fine Arts, Moscow). Both works are illustrated in Shackelford and Frèches-Thory, *Gauguin Tahiti*, pp. 31 and 53, respectively.

36. For an illustration of the Louvre drawing, see Lawrence Gowing, letter to the editor, *Burlington Magazine*, vol. 91, no. 561 (December 1949): 354. See also Yann le Pichon, *Gauguin: Life, Art, Inspiration*, trans. I. Mark Paris (New York: Abrams, 1987),

p. 215; and Musée Départemental du Prieuré, *Le chemin de Gauguin, genèse et rayonnement*, 3rd ed., exh. cat. (Saint-Germain-en-Laye, France: Musée Départemental du Prieuré, 1986), p. 180. On Gauguin's sources of inspiration, see Stephen F. Eisenman, *Gauguin's Skirt* (New York: Thames and Hudson, 1997), pp. 145–47.

37. See, for example, Gauguin's *Breton Eve (I)*, *Breton Eve (II)*, and *Women Bathing* in Wildenstein, *Savage in the Making*, cats. 333–35, respectively. See also Wayne V. Andersen, *Gauguin's Paradise Lost* (New York: Viking, [1971]), pp. 89–90, and "Gauguin and a Peruvian Mummy," pp. 238–42, fig. 78.

38. For a discussion of Poussin's painting, see Pierre Rosenberg, catalogue entry in *Nicolas Poussin, 1594–1665*, by Pierre Rosenberg and Louis-Antoine Prat, exh. cat. (Paris: Réunion des Musées Nationaux, 1994), pp. 203–5, cat. 44.

39. By Gauguin's time Poussin's *Flora* was one of the prized possessions of the Gemäldegalerie in Dresden. It is possible that Gauguin obtained an impression of the engraving made of the picture in 1686 or a copy of the reproduction of it in the edition of Poussin's works published by Firmin-Didot in 1845. But both of these reverse the image, and Gauguin's quotations argue for a direct reproduction. A photograph of the painting was retailed by the Paris firm Adolphe Braun and listed as number 717 in the firm's 1887 catalogue of available reproductions, each priced at fifteen francs. See *Oeuvres complètes de Nicolas Poussin*, 2 vols. (Paris: F. Didot, 1845). I am grateful to Geneviève Plonge of the Musée du Louvre in Paris for providing me with the reference to this

publication. See also Braun et Cie, *Catalogue général des photographies inaltérables au charbon et héliogravures faites d'après les originaux peintures, fresques, dessins et sculptures des principaux musées d'Europe, des galeries et collections particulières les plus remarquables* (Paris: Ad. Braun, 1887), p. 23, no. 717. I am grateful to Nicholas Wise of the Frick Collection in New York for finding this catalogue reference.

40. Fontainas, "Revue du mois: Art moderne," in *Mercure de France*, vol. 29 (January 1899): 238 (my translation).

41. Gauguin to Fontainas, March 1899, in Malingue and Stenning, *Letters to His Wife and Friends*, p. 217, no. 170. See also Jules Huret, "Interview with Stéphane Mallarmé," in *Enquête sur l'évolution littéraire* (Vanves, France: Editions Thot, 1982), p. 77. First published in *L'écho de Paris*, March 3, 1891.

42. Gauguin to Fontainas, August 1899, p. 221, no. 172.

43. Gauguin to Morice, July 1901, in Malingue and Stenning, *Letters to His Wife and Friends*, p. 227, no. 174.

44. See Aimée Brown Price, *Pierre Puvis de Chavannes* (New York: Rizzoli, 1994), 183–86, 199–201, 213–16.

45. Marina Ferretti-Bocquillon et al., *Signac, 1863–1935* (New York: Metropolitan Museum of Art, 2001), no. 75, 195–200.

46. See Berson, *The New Painting*, II: *Documentation*, 242–44, 260–63.

47. On these ancillary canvases, see George T. M. Shackelford, "*Where Do We Come From?*," in Shackelford and Frèches-Thory, *Gauguin Tahiti*, p. 184.

48. Gauguin to Monfreid, December 12, 1898, p. 71 (translation modified).

49. Chaudet to Gauguin, photocopy of typed transcription of letter, January 15, 1899, in

Service du Documentation, Musée d'Orsay, Paris.

50. For Vollard's relations with the Nabis and with Picasso, see Gloria Groom, "Vollard, the Nabis, and Odilon Redon," and Gary Tinterow, "Vollard and Picasso," in *Cézanne to Picasso: Ambroise Vollard, Patron of the Avant-Garde*, ed. Rebecca A. Rabinow, exh. cat. (New York: Metropolitan Museum of Art, 2006), pp. 82–99 and 100–117, respectively. Matisse obtained Gauguin's *Young Man with a Flower* (1891; Mavromatis Collection, New York). See Georges Wildenstein, *Gauguin* (Paris: Beaux-Arts, 1964), no. 422.

51. Morice to Gauguin, May 22, 1901, in *Lettres de Gauguin à Daniel de Monfreid*, ed. Victor Segalen and A. Joly-Segalen, rev. ed. (Paris: G. Falaize, 1950), pp. 217–18.

52. Gauguin to Monfreid, July 1901, p. 87. Gauguin to Morice, July 1901, no. 174, pp. 227–28.

53. Gauguin to Morice, July 1901, no. 174, pp. 227–28.

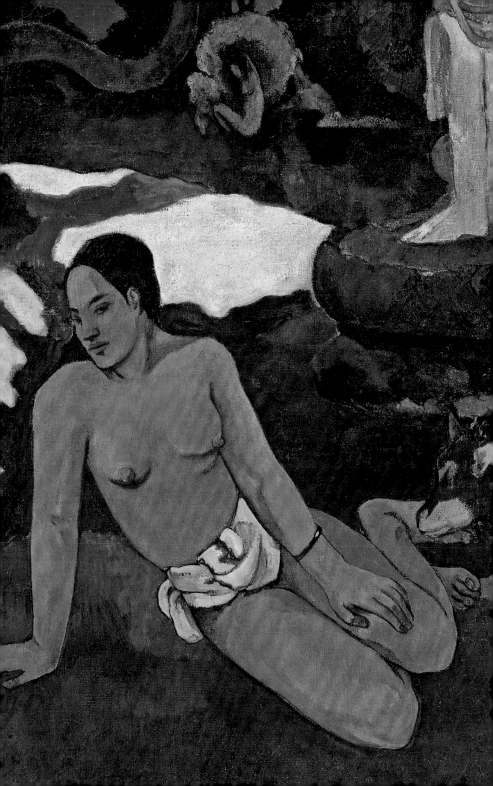

FIGURE ILLUSTRATIONS

p. 11
Landscape with Two Breton Women, 1889
Oil on canvas
72.4 x 91.4 cm (28½ x 36 in.)
Museum of Fine Arts, Boston
Gift of Harry and Mildred Remis and
Robert and Ruth Remis, 1976.42

p. 12
Self-Portrait *with Yellow Christ*, 1890–91
Oil on canvas
38 x 46 cm (15 x 18⅛ in.)
Musée d'Orsay, Paris
Acquired with the help of Philippe Meyer
and Japanese funding coordinated by the
newspaper *Nikkei*, RF 1994-2
Photograph © RMN — R. G. Ojeda

p. 13
Jar in the Form of a Grotesque Head, 1889
Glazed stoneware
28.4 x 21.5 cm (11⅛ x 8½ in.)
Musée d'Orsay, Paris
Gift of Jean Schmit to the Musée du Louvre, 1938,
OA 9050
Photograph © RMN — Hervé Lewandowski

p. 14
Be in Love and You Will Be Happy, 1889
Painted linden wood
95 x 72 x 6.4 cm (37⅜ x 28⅜ x 2½ in.)
Museum of Fine Arts, Boston
Arthur Tracy Cabot Fund, 57.582

p. 18
Manao tupapau (*The Spirit of the Dead Watching*), 1892
Oil on burlap mounted on canvas
72.4 x 92.4 cm (28½ x 36⅜ in.)
Albright-Knox Art Gallery, Buffalo, New York
A. Conger Goodyear Collection, 1965:1

p. 21
Merahi metua no Tehamana
(*The Ancestors of Tehamana*), 1893
Oil on coarse canvas
75 x 53 cm (29½ x 20⅞ in.)
The Art Institute of Chicago
Gift of Mr. and Mrs. Charles Deering McCormick,
1980.613
Photograph © The Art Institute of Chicago

p. 22
Te arii vahine (*The Noble Woman*), 1896
Oil on canvas
97 x 130 cm (38⅛ x 51⅛ in.)
The State Pushkin Museum of Fine Arts, Moscow
Photograph © Art Resource, NY— Erich Lessing

p. 24
Te tamari no atua (*The Child of God*), 1896
Oil on canvas (hemp)
96 x 129 cm (37½ x 50½ in.)
Bayerische Staatsgemäldesammlungen,
Neue Pinakothek, Munich

p. 31
Illustrated letter to Daniel de Monfreid,
February 1898
Ink and watercolor on paper
27 x 20.4 cm (10⅝ x 8 in.)
Musée d'Orsay, held by the Département
des Arts Graphiques, Musée du Louvre,
Paris, RF 41 648
Photograph © RMN — Gérard Blot

following page 32:
Where Do We Come From? What Are We?
Where Are We Going? 1897–98
Oil on canvas
139.1 x 374.6 cm (54¾ x 147½ in.)
Museum of Fine Arts, Boston
Tompkins Collection, 36.270

p. 34
Sandro Filipepi, called Botticelli
(Florentine, 1445–1510)
Allegory of Spring (*La Primavera*), about 1481
Tempera on wood
203 x 314 cm (79⅞ x 123⅜ in.)
Galerie degli Uffizi, Florence
Courtesy of the Ministero dei Beni e la
Attività Culturali

p. 35
Nave nave mahana (*Delightful Day*), 1896
Oil on canvas
95 x 130 cm (37⅜ x 51⅛ in.)
Musée des Beaux-Arts, Lyon, France, B 1038
Photograph © Studio Basset

p. 37
Nicolas Poussin (French, 1594–1665)
The Realm of Flora, 1631
Oil on canvas
131 x 181 cm (51⅝ x 71¼ in.)
Staatliche Kunstsammlungen, Gemäldegalerie
Alte Meister, Dresden

pp. 38–39
Pierre Puvis de Chavannes (French, 1824–1898)
Inter Artes et Naturam, 1890
Oil on canvas
293 x 829 cm (115¼ x 326¼ in.)
Musées de la Ville de Rouen, 888.3.1
Photograph © Musées de la Ville de Rouen,
Catherine Lancien/Carole Loisel

p. 41
Georges Seurat (French, 1859–1891)
A Sunday on La Grand Jatte — 1884, 1884–86
Oil on canvas, 200 x 300 cm
(6 feet 9¾ in. x 10 feet 1¼ in.)
The Art Institute of Chicago
Helen Birch Bartlett Memorial Collection,
1926.224

BOSTON

MFA Publications
Museum of Fine Arts, Boston
465 Huntington Avenue
Boston, Massachusetts 02115
www.mfa.org/publications

Support for this publication was provided by the
Ann and William Elfers Publications Fund.

© 2013 by Museum of Fine Arts, Boston
Text adapted from "Trouble in Paradise," by
George T. M. Shackelford, in *Gauguin, Cézanne,
Matisse: Visions of Arcadia*, © 2012 by
Philadelphia Museum of Art

ISBN 978-0-87846-793-8
Library of Congress Control Number: 2013932916

While the objects in this publication necessarily
represent only a small portion of the MFA's
holdings, the Museum is proud to be a leader
within the American museum community in
sharing the objects in its collection via its website.
Currently, information about more than 330,000
objects is available to the public worldwide. To
learn more about the MFA's collections, including
provenance, publication, and exhibition history,
kindly visit *www.mfa.org/collections*.

For a complete listing of MFA publications,
please contact the publisher at the above
address, or call 617 369 3438.

All illustrations in this book were photographed
by the Imaging Studios, Museum of Fine Arts,
Boston, except where otherwise noted.

Series design by Susan Marsh
Typeset in Filosofia, Meta Pro Light, and Gotham
by Matt Mayerchak
Book design and production by Terry McAweeney
Printed and bound at CS Graphics Pte Ltd

Available through ARTBOOK | D.A.P.
155 Sixth Avenue, 2nd floor
New York, New York 10013
Tel.: 212 627 1999 · Fax: 212 627 9484
www.artbook.com

Printed and bound in Malaysia
This book was printed on acid-free paper.